DISCARD

GARBAGE

ZZ^{ZZ}

GARBAGE

Mathew Reichertz

INTRODUCTION

Discussing *Garbage* in relation to the tradition of comics and graphic novels requires that we have some sense of what that tradition is. Few subjects, however, have provoked so many words to such little effect as the search for what Thierry Groensteen has called "the impossible definition."[1]

Mathew Reichertz's painting installation, which I had the pleasure of walking around inside at Carleton University Art Gallery, promised to turn the gallery itself into a comic book. In a manner of speaking, he's done it again here.

Or has he?

Without choosing between them, I offer here three different ways of defining what comics are and, accordingly, three different ways that *Garbage* might (or might not) be a comic book.

First, we could inventory formal properties that distinguish comics from other media. Early comics scholarship typically followed this route. One of the most obvious is the exaggerated and simplified visual style we call "cartooning." Cartooning helps the reader accept other aspects of the comic's heightened reality, such as speech and thought bubbles, sound effects, and speed lines. While artwork in comics rarely approaches the realism available to a painter, painted comic art has a certain cachet—though these artists typically eschew the specifically cartoony conventions that Reichertz embraces. Although *Garbage* employs a mix of visual styles, the narrative's "primary" reality is grounded in a relatively realistic style that, when mixed with cartoon iconography, creates a sense of uneasiness that undergirds the narrative.

Second, many critics point to *mise-en-page*, the distribution of images in space, as comics' particular genius. Reichertz establishes relationships between images that recall the medium-specific division of pages and some traditional strategies for dividing the page into panels. This format's familiarity establishes a rhythm that drives the viewer past the lacunae in his narrative—to a certain extent, past the individual images themselves. In a way that is reminiscent of Scott McCloud's "infinite canvas" experiments,[2] however, Reichertz eventually abandons the "page": in the gallery, images explode across the walls; in this book, across gatefold pages. Towards the end, panels disappear, too. Without their containers, what remain are only relationships between images in space.

Third, whatever else they may be, "comics" and "graphic novels" are cultural and industrial categories. They are labels that indicate a bundle of expectations about a work's style and format and the spaces in which it circulates. Arguably, the original installation—by a painter, in an art gallery—was not comics, while this volume—released by a graphic-novel publisher at a comics festival, and featuring commentary by a comics scholar like yours truly—is.

Once, comics and fine art were mutually exclusive categories—with the former perhaps paying homage to the latter, the latter at times appropriating conventions from the former, and each move serving to preserve the fundamental divide it appears to bridge. But I think *Garbage* is different. Equally at home in the art world and the comics world, it uses and refuses the conventions of graphic novels. *Garbage* is both art and "Art," just as it is and isn't comics.

— Benjamin Woo, Ottawa, 2016

1. Thierry Groensteen, *The System of Comics*, trans. Bart Beaty and Nick Nguyen (Jackson, Mississippi: University Press of Mississippi, 2007), p. 12.
2. See Scott McCloud, *Reinventing Comics* (New York: Harper Collins, 2000).

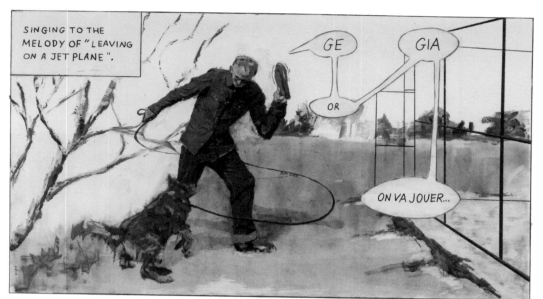

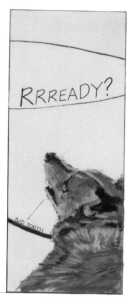

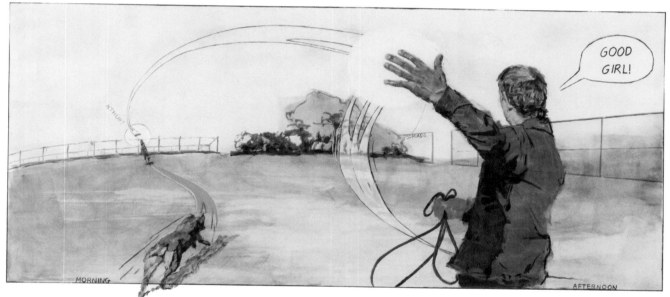

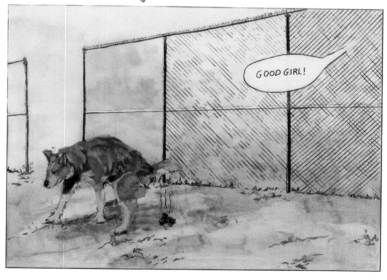

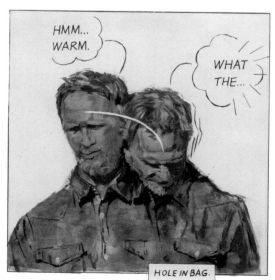

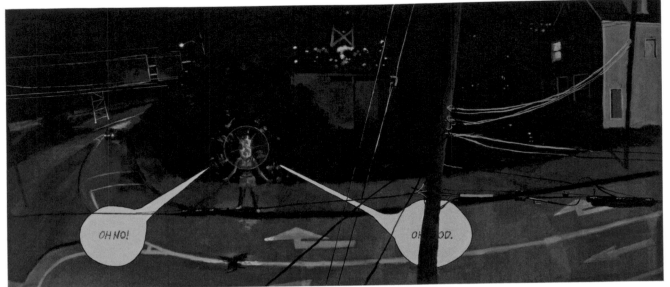

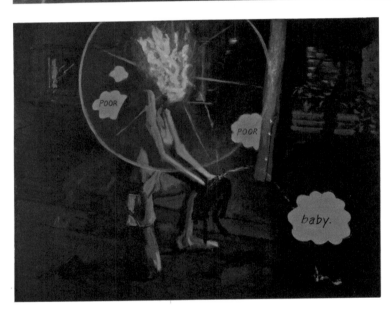

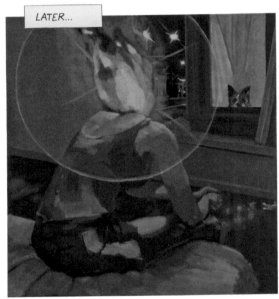

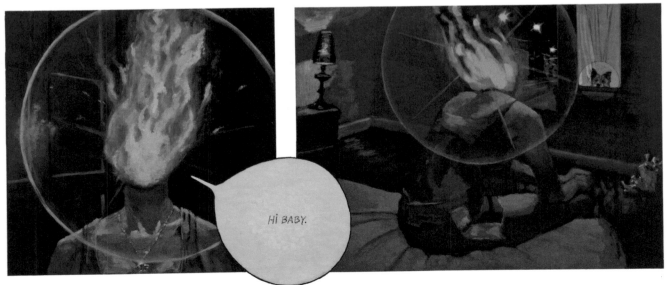

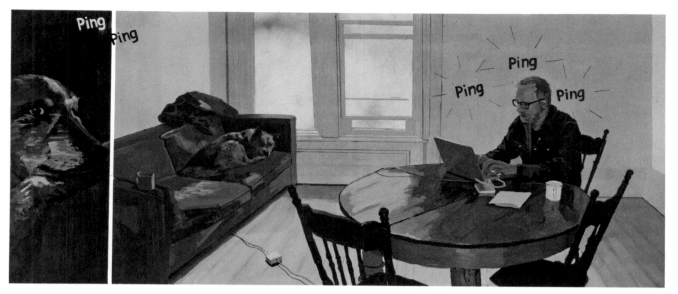

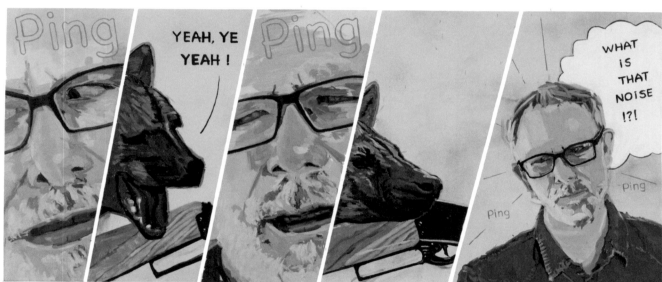

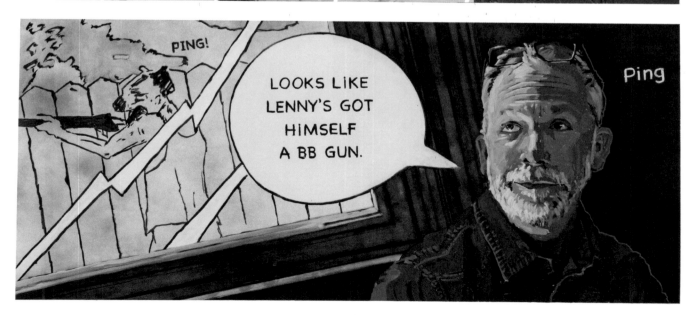

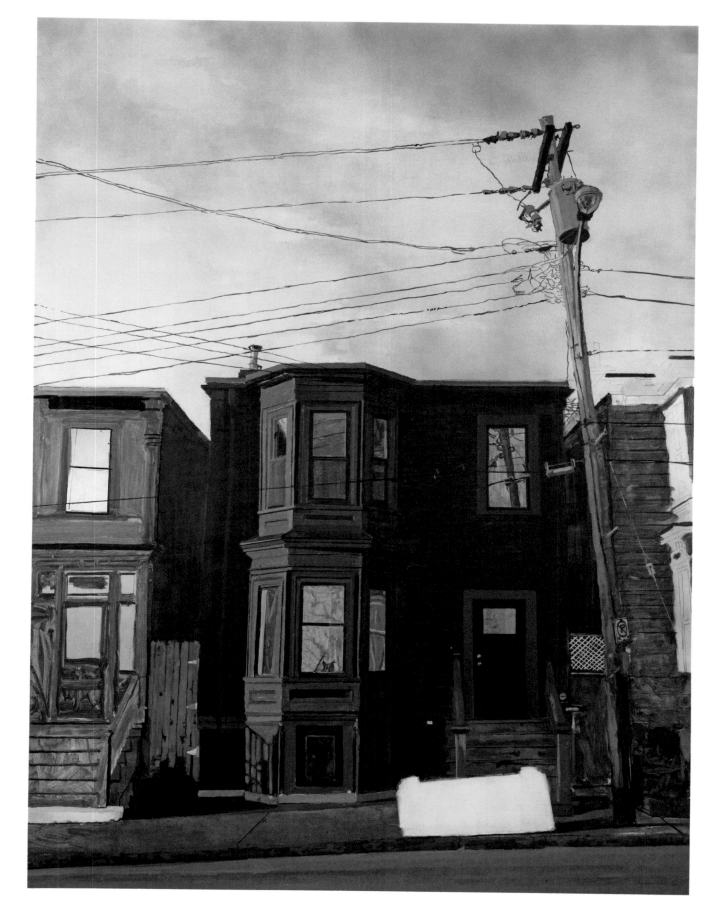

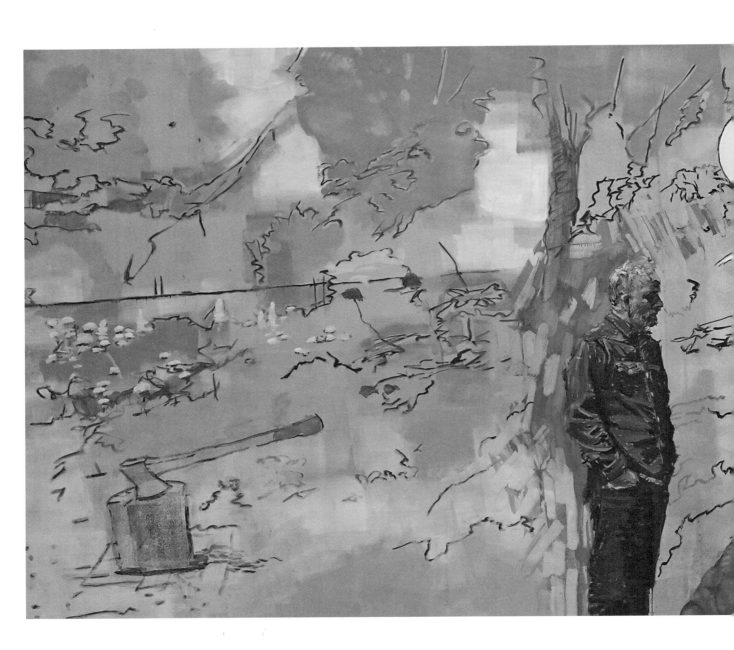

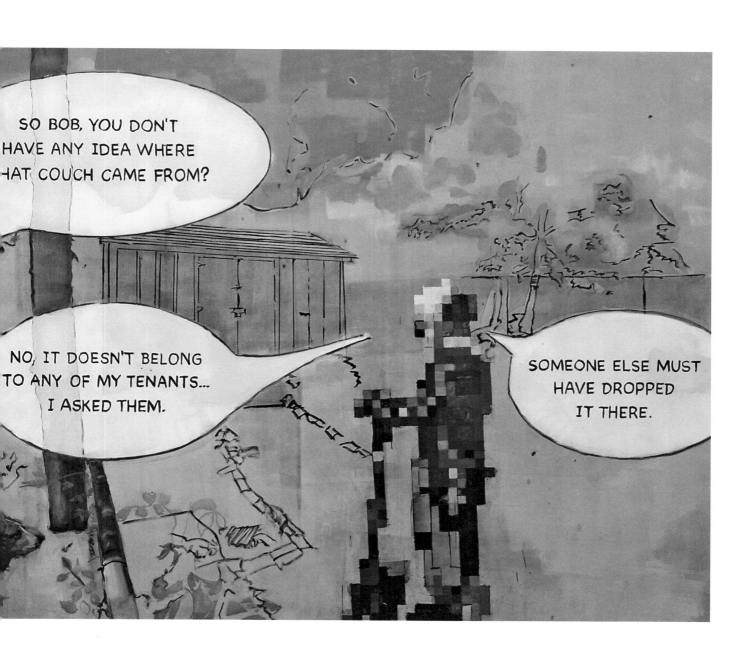

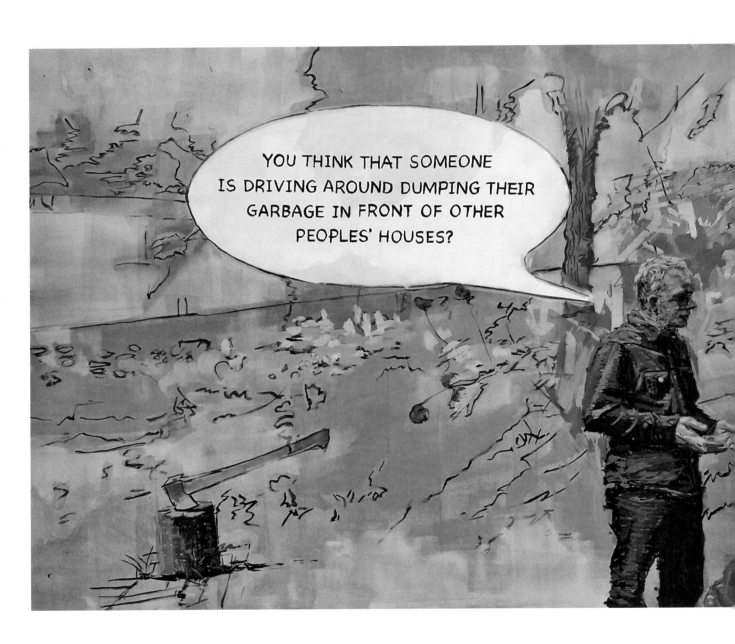

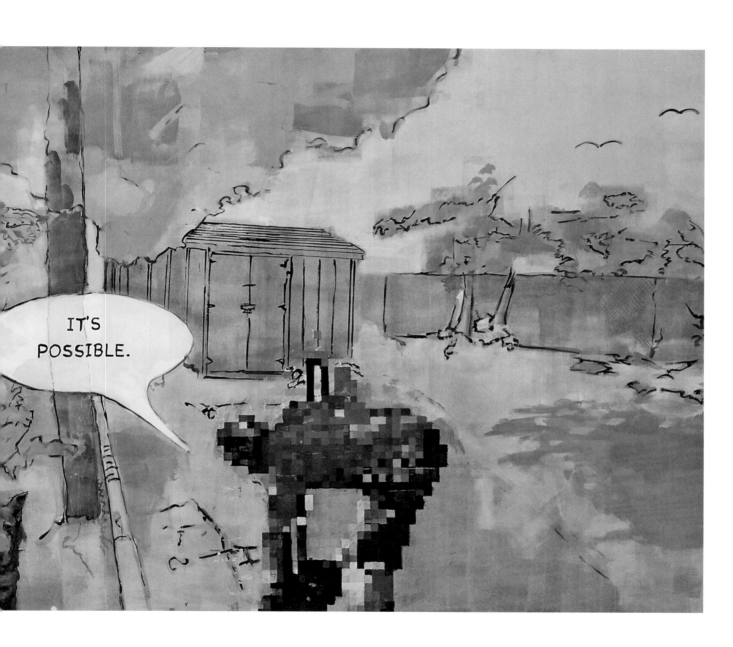

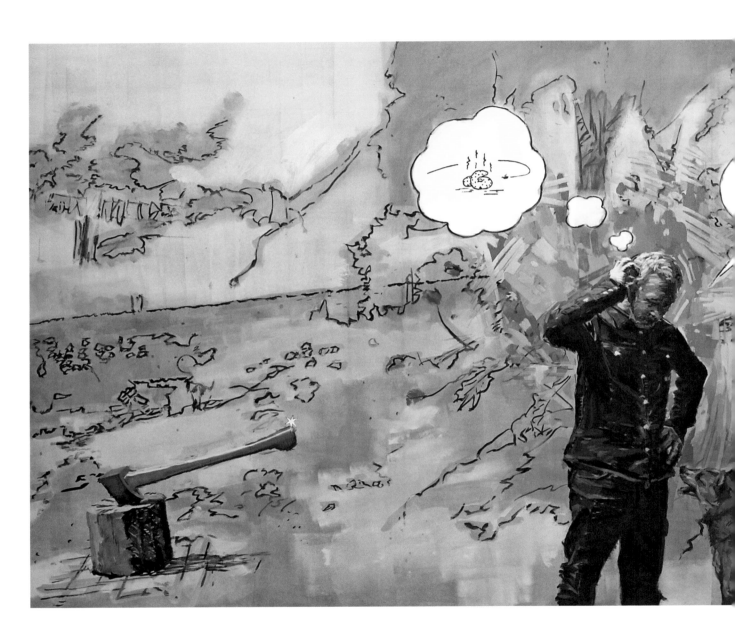

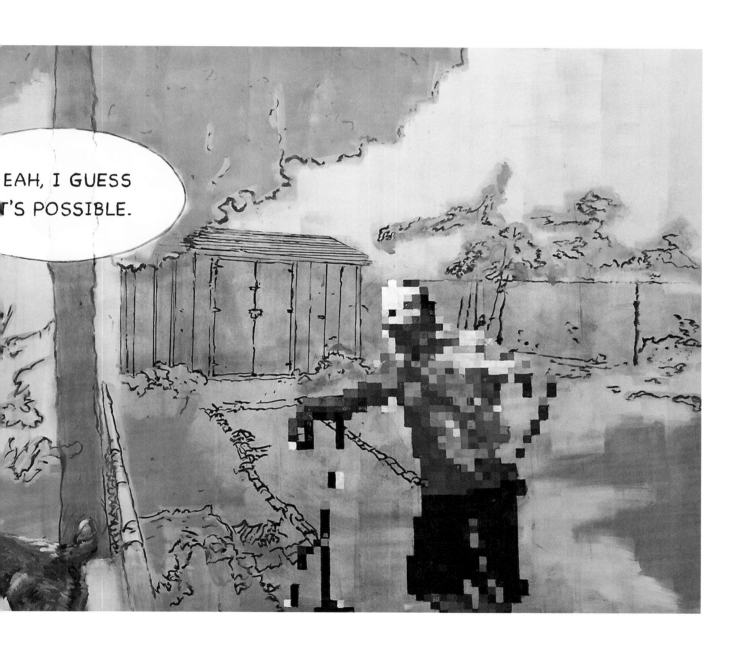

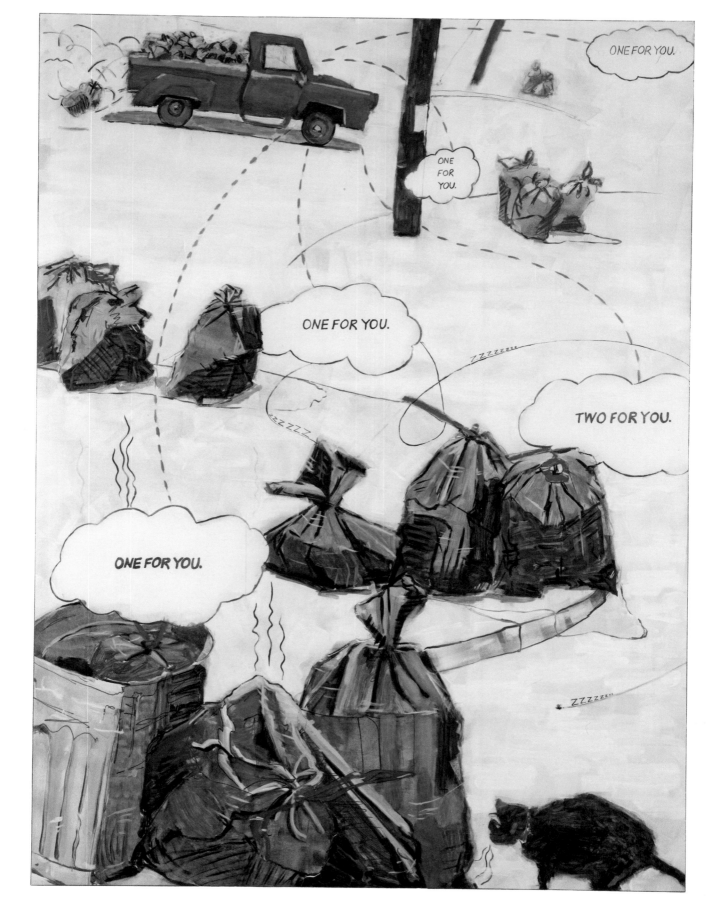

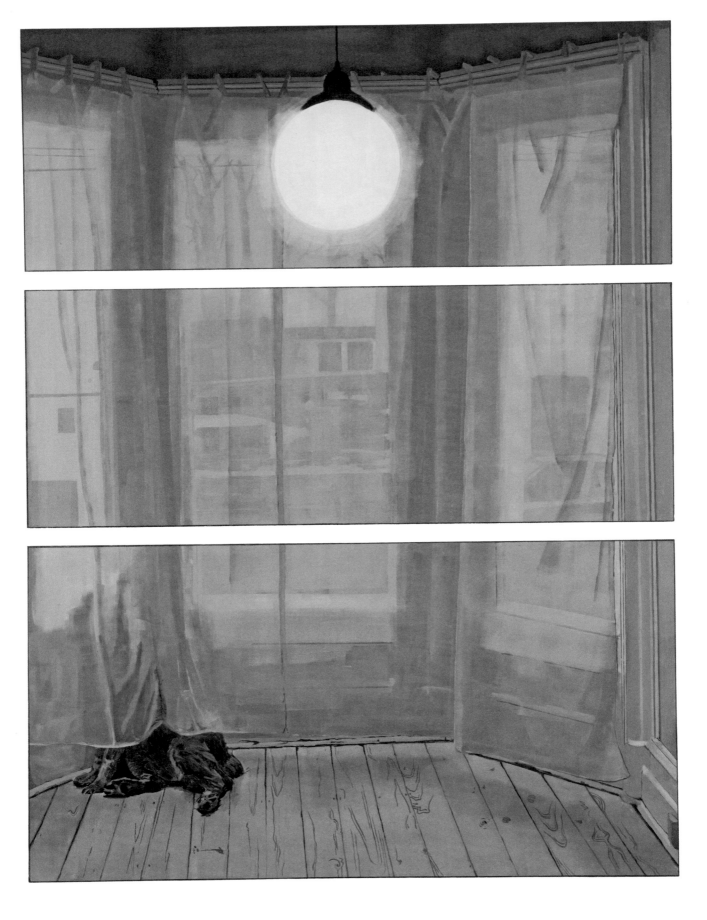

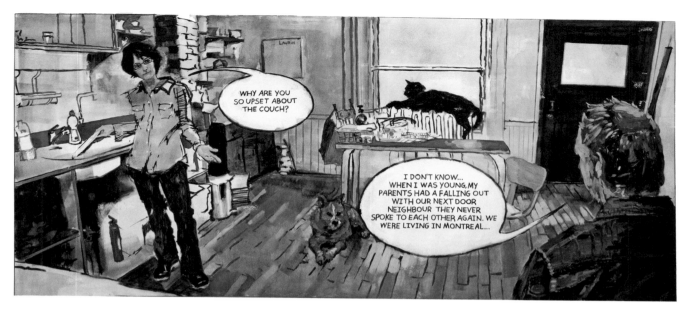

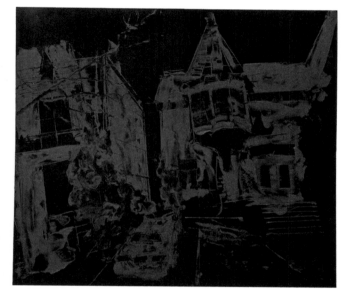

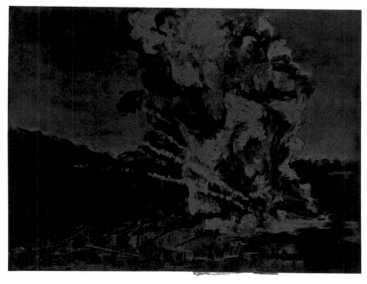

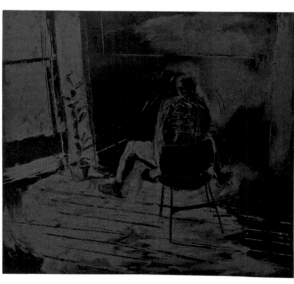

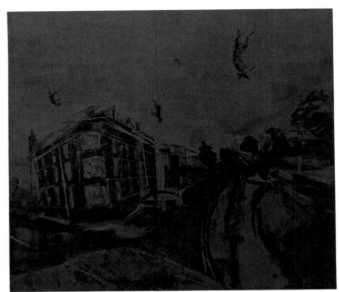

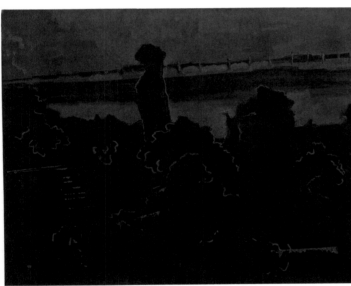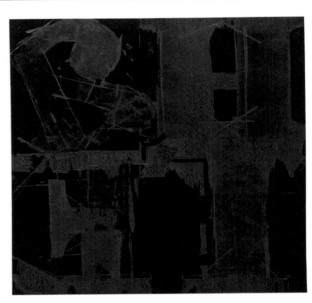

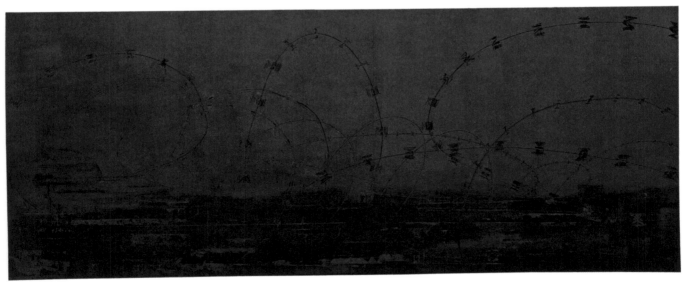

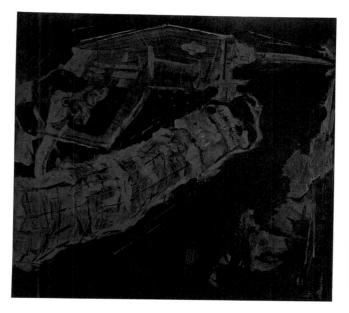

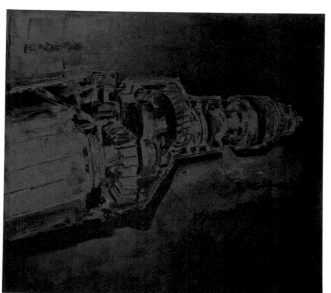

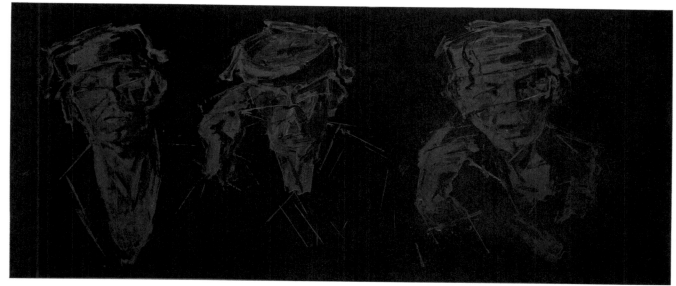

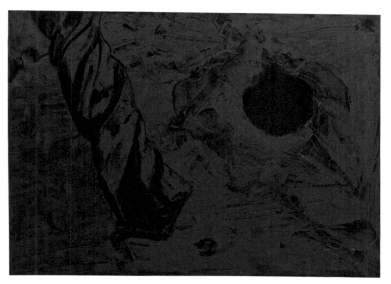

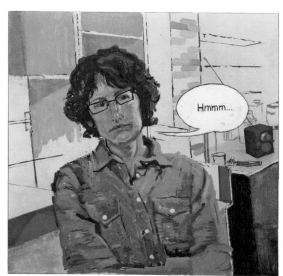

Hmmm...

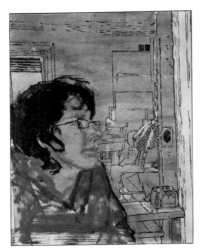
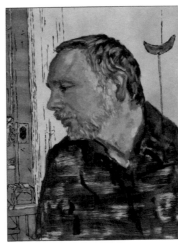
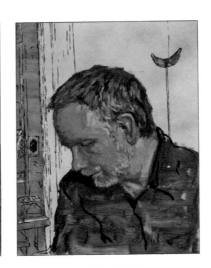
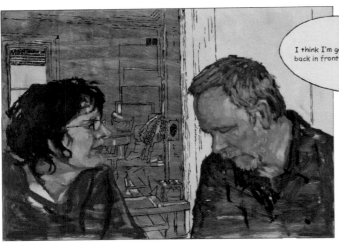
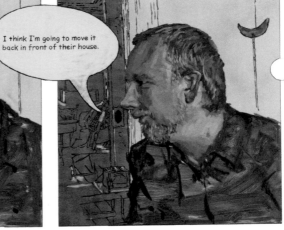

I think I'm going to move it back in front of their house.

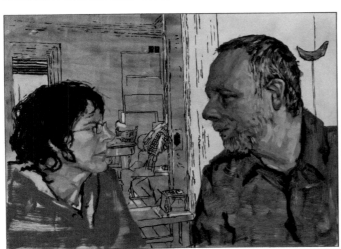
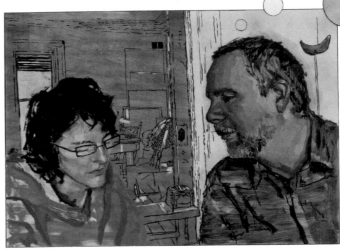

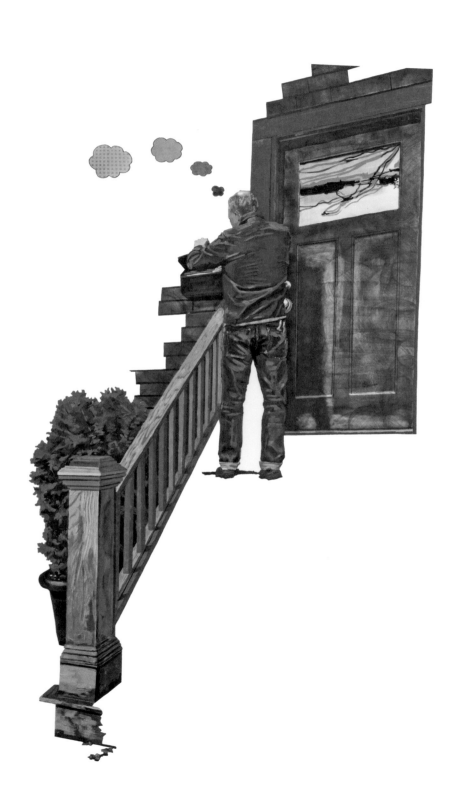

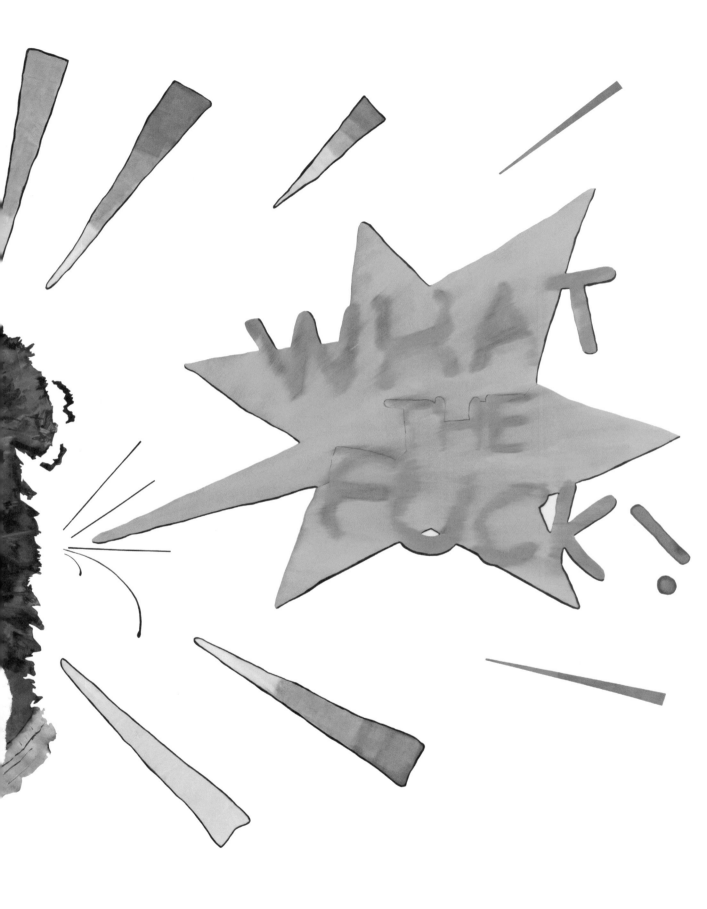

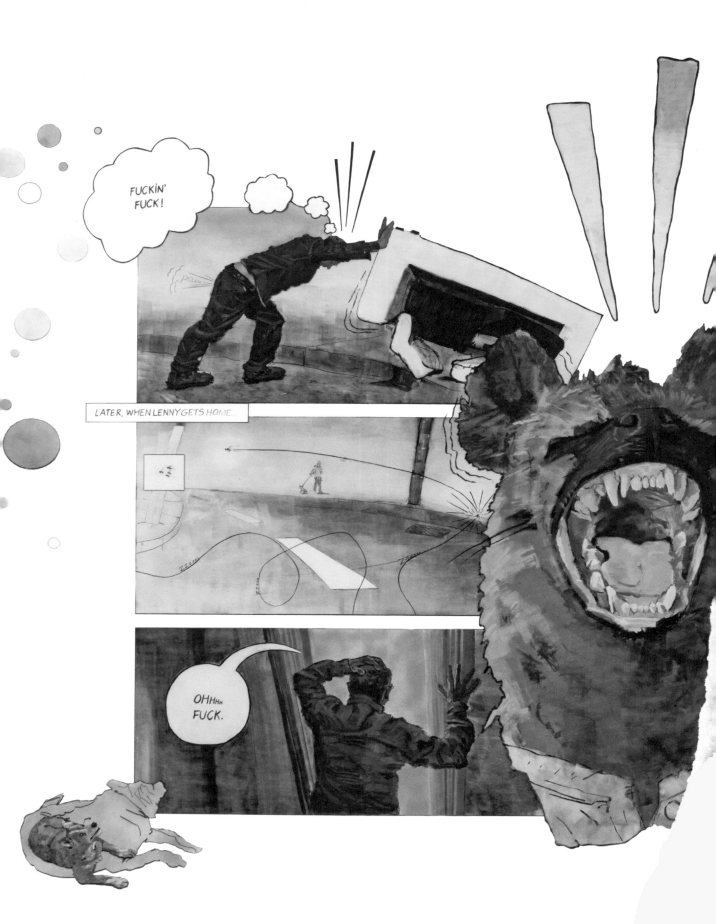

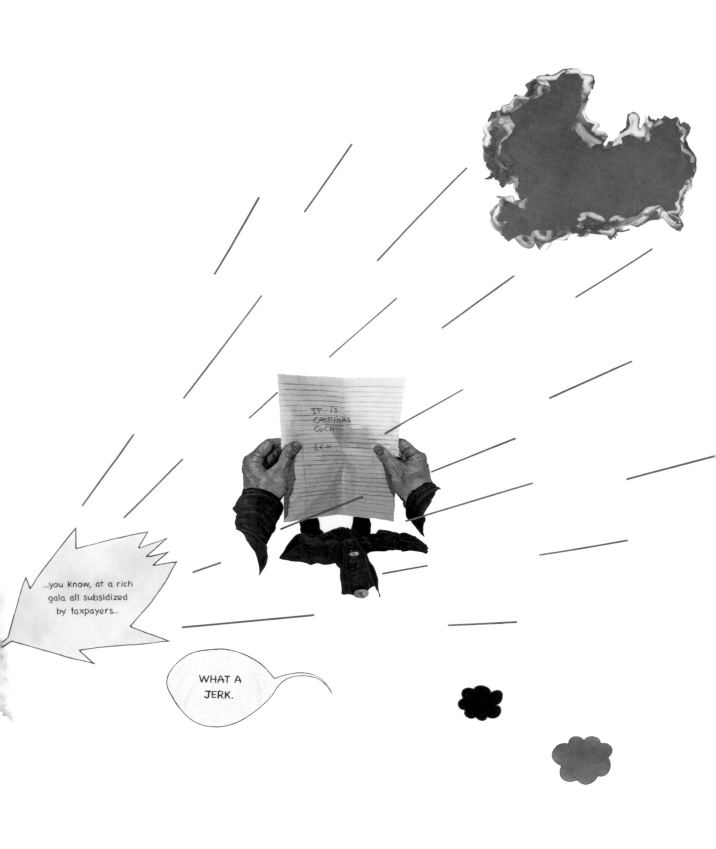

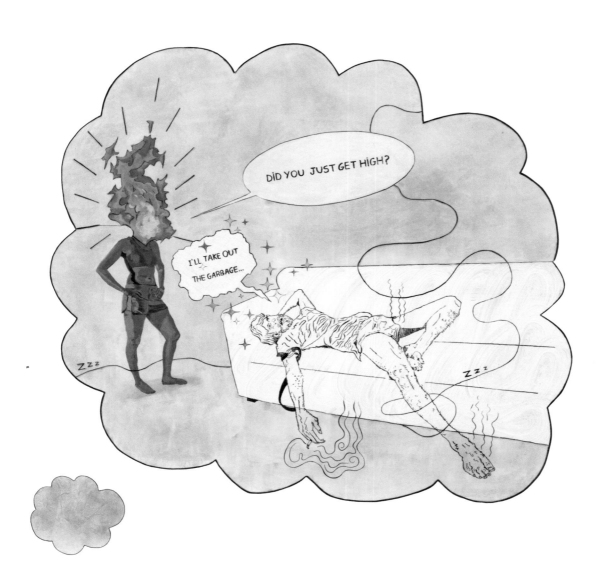

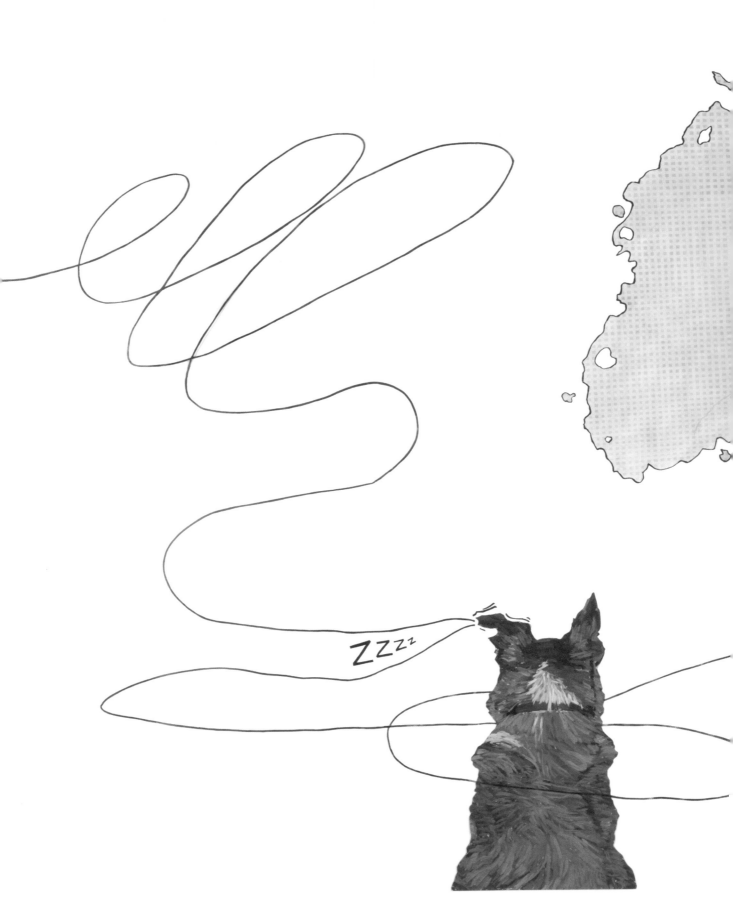

ZZ^{zz}

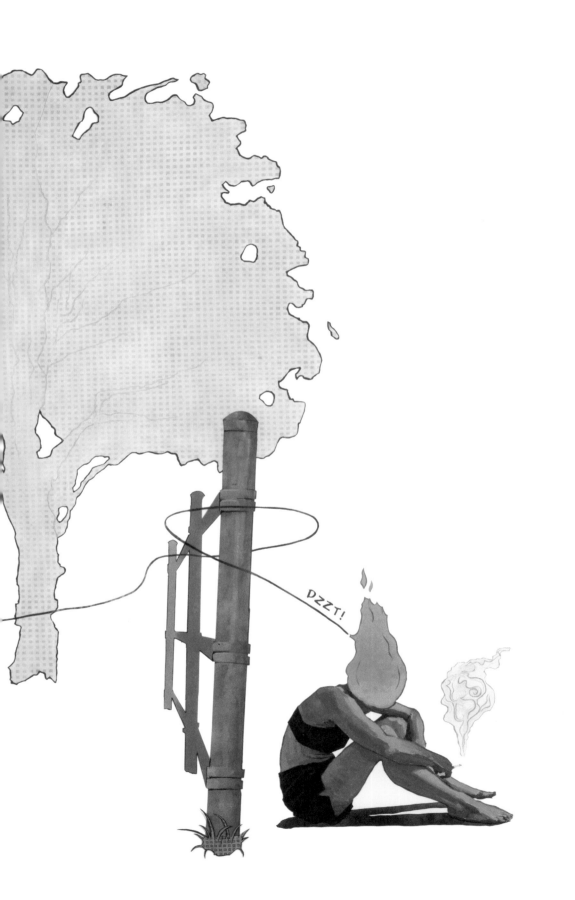

DZZT!

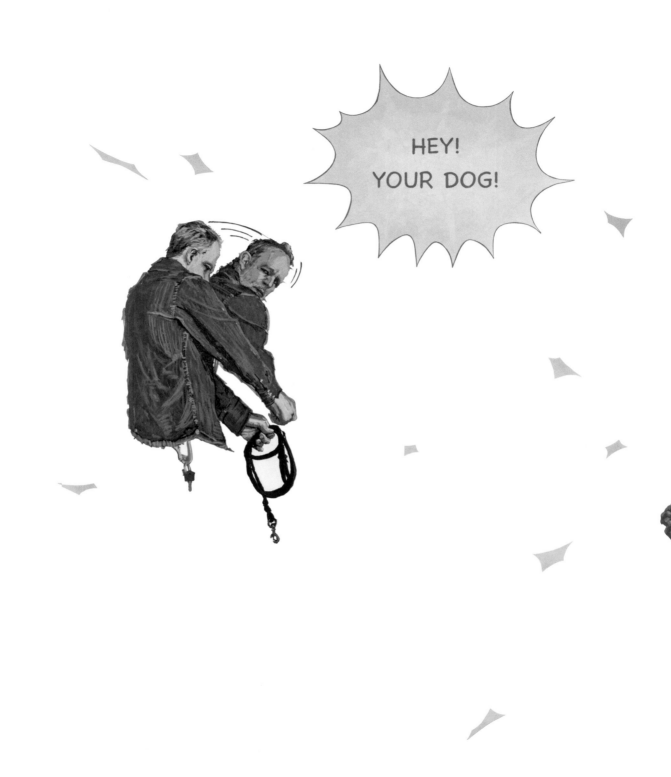

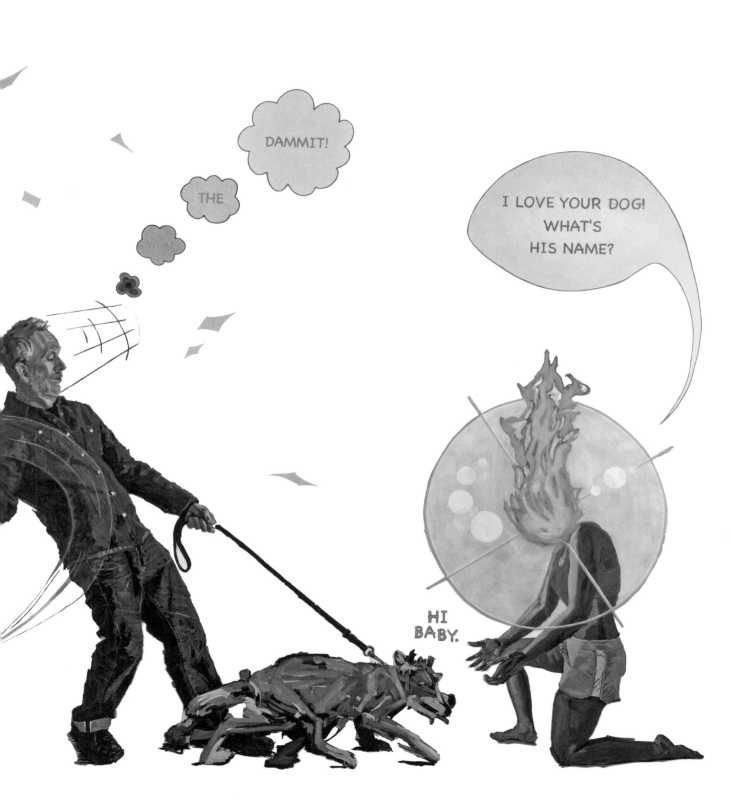

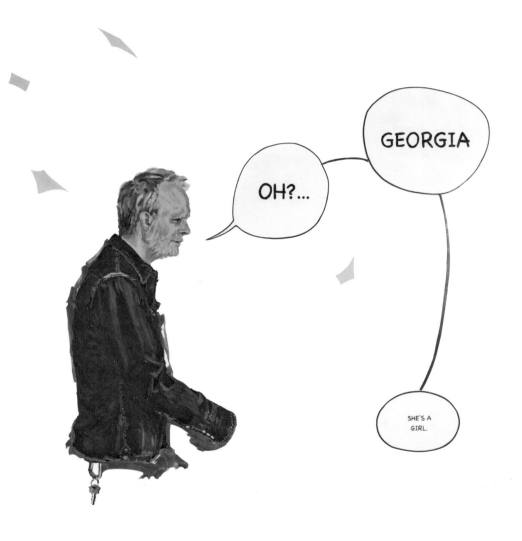

A DESIGN FOR A PAINTING OF THE SAME SIZE

Perversely, in our age of virtual reality headsets and other immersive technologies, there is no environment more persuasively immersive than the book. Once we enter its pages we are happily lost to all that is outside its covers.

An art gallery can hardly compete. Catching and holding the visitor's attention is a battle that those of us who work in galleries are constantly waging. Our ideal of the white cube, where the viewer's encounter with the artwork is isolated from all distractions, remains illusory, its emptiness contaminated by electrical outlets and baseboards and exit signs. Extended labels may command from visitors more committed attention than the works on display. The physically enveloping nature of the gallery, paradoxically, also means that it contains bored security staff pacing about, and tourists taking selfies in front of the art. It contains our own bodies, conscious as we are of navigating the space even as we read it.

It is precisely the intimate scale of the book that allows the reader to detach its imaginative universe—whether generated by printed text, or images, or a combination of the two—from the world that goes about its business beyond the edges of the page.

The physical form of the book has not substantially changed since the codex first appeared in common use, in Egypt and Rome, in the first century CE, supplanting the scroll in those cultures by the fourth century. Codices have often integrated both text and image, whether illuminated manuscripts from medieval Europe, or Mayan codices produced after that culture's invention of a superior form of paper, called *huun*, in the fifth century.[1]

In both Europe and the Middle East, early books in the codex form were vehicles for the wide dissemination of religious texts—the Bible and the Qur'an—within traditions that tend in varying degrees towards the aniconic rejection of imagery in association with the sacred word.[2] Perhaps that is why, within modern Western literature, imagery is deemed superfluous, or at best subsidiary, to text. We tend to view novels, illustrated stories, and comics as mutually exclusive categories—associated, respectively, with presumed readerships of adults, children, and unruly adolescents. Of course, with the emergence of comics studies, and the burgeoning of the graphic novel form, comics have now entered academic discourse.[3] Nevertheless, the coolness of contemporary comics continues to derive partly from their association with marginal cultural forms.

Conversely, within Western visual arts, text has generally been deemed secondary to other forms of visual experience. Far Eastern scroll painting represents a different tradition, in which text and image elegantly complement one another. In Western culture, however, it seems that both the pictorial and the textual tend to lose status when combined.

Why, then, would a painter such as Mathew Reichertz choose to produce paintings in the form of giant comic book pages, employing many of the compositional and graphic conventions of drawn, narrative images in print?

Reichertz, who teaches narrative painting at NSCAD University (the Nova Scotia College of Art and Design, in Halifax), has explored storytelling in his work for many years. Two early suites of work, *necessary man* (1999) and *Romanian Debacle* (2004), present arrays of individual figures, vignettes, or scenes that collectively refer to narratives arising from the artist's experiences or from events at the art gallery at which he was employed.[4] Not presented within a clear sequence or shared pictorial field, they invite the viewer to construct a story by connecting the dots. The work for which Reichertz was the Eastern Regional Winner in the 2005 RBC Canadian Painting Competition was from a series called *Tiny Town*, in which he combined imagery found on the Internet with tableaux of small toys set up in his studio to stage "somewhat believable pictorial spaces"[5] in which enigmatic and disturbing events are happening, are about to happen, or have just happened. His 2006 series *The Fight* stages violent interactions between figures, some resembling the artist, in familiar public spaces of Halifax. Both series combine the quotidian with the perplexing and the implausible or impossible.

Garbage, by contrast, is generally realistic, except for the mythological (or superhero) attributes, animal and otherwise, of various characters. The hyena head of the neighbour, Lenny, echoes the canid head of the Egyptian god Anubis,[6] while Christina, the Firehead Woman (as Reichertz sometimes refers to her), alludes to such comics superheroes as Marvel's Ghost Rider, or Human Torch from The Fantastic Four, or DC Comics' Firestorm. The only characters with realistic faces are the protagonist and his spouse, modelled on Reichertz and his partner, living in a house and neighbourhood identical to his own, that of Halifax's rapidly gentrifying North End.

Through the series of paintings that constitutes *Garbage*, Reichertz employs a coherent, plausible narrative structure built upon the conventional armature of comics. These include images, framed in rectangular outlines corresponding to comics panels, together forming larger panels that act as pages. As in English-language comics, their sequence generally flows from left to right and top to bottom, following the conventions of printed text. In cultures where written text reads in the opposite direction, so does the narrative sequence of comics art—for instance, in Japanese manga that begin on what for English speakers would be the final page.[7]

An early "page" in *Garbage*, illustrating an incident with a BB gun, demonstrates several principles that Scott McCloud has noted regarding the expression of time duration in comics, such as that longer panels convey the passage of more time.[8] Consider the first panel on the BB gun page, a small one showing the alert head of the dog, Georgia, along with the single word, *Ping*. A second *Ping* bridges to a much wider panel showing the protagonist keyboarding on a laptop, with three more *Ping*s circling around his head. The middle tier of panels alternates between narrow close-ups of the protagonist's face and that of a hyena (representing Lenny), with a gun, saying "Yeah, ye yeah!" The oblique lines or slashes that separate them suggest rapid alternation between two simultaneous events. The bottom tier consists of a single panel, showing the head and shoulders of the protagonist, saying, "Looks like Lenny's got himself a BB gun," with a hyena-headed Lenny visible behind him, through a window.

Other than the placement of panels sequentially on pages, the other most obvious comics convention Reichertz uses is the direct insertion of text and graphic symbols to represent

speech, thought, feelings, sound, and dynamic action. The convention of the speech, or dialogue, balloon evolved from "speech scrolls" that date back at least to the thirteenth century in European art, and to the seventh to tenth centuries in Mesoamerican art. "Word balloons," or *banderoles*, appeared in eighteenth-century broadsheets, particularly in political cartoons.[9] When Richard F. Outcault's *The Yellow Kid*, usually considered the first mass-circulation comic strip, appeared in US newspapers in 1895, speech was shown on the surface of the title character's shirt.[10] Speech balloons of the modern sort appeared almost immediately thereafter, in 1896.[11]

Reichertz deploys the full range of cartoon balloon conventions, starting with speech bubbles with tails or pointers emanating from the mouths of speakers. An interpolated rectangle, or caption, at the top of a panel on an early page, the one introducing Firehead Woman (Christina, whose name we do not yet know), reads "Later..." and serves as a form of narrative notation. There are thought bubbles, as for the protagonist's "What...the...Dammit!" when Christina finally meets Georgia. There is even a small drawing of a stinking pile of dog poo—the stink conventionally represented by wiggly ascending lines—within a thought bubble rising from the protagonist's head while he considers the suggestion that someone is randomly distributing garbage in his neighbourhood. The next page, where he envisions a red pickup truck delivering trash, is the first to dissolve the standard panel outline, fusing the whole "page" into a fluid sequence of events. Reichertz plots the truck's various sorties about the page with dotted red lines.

The conventional scream bubble, with jagged outlines, occurs when Christina calls out, "Hey! Your dog!", and most dramatically when Lenny erupts with "What the Fuck!" on discovering that the contentious sofa has been moved to his side of the property line. Reichertz remains within the comics universe even as Lenny's rage blows the roof off the page itself.

Reichertz improvises on the convention of the thought bubble to lead us from the quiet preceding scene, between the protagonist and his spouse, to Lenny's explosion. He creates a trail of blue and white bubbles, void of text. In the gallery, these helped to negotiate spatial transitions—at Saint Mary's University Art Gallery, from one wall surface to another, recessed by a few inches; at Carleton University Art Gallery, around a corner into a different room.

Within the narrative sequence, Lenny's outburst initiates a departure from the standard page format into a series of detached elements that float completely free of panel constraints and expand into open space. McCloud proposes that borderless panels, or ones that bleed to the edge, suggest timelessness.[12] In *Garbage*, the image's escape from the panel outline gives an immediacy and intensity to the action and scrambles sequentiality. This climactic section of the story is where the function of the images differs most in a gallery space from in a book. The gallery allows different pages to be viewed at the same time, making it seem as if they might be happening at once. A narrative thread is represented, almost literally, by a meandering, thin black line: the flight path of a buzzing fly. It links disparate elements and leads the protagonist, tugged behind his leashed dog, to an encounter with Christina, the mysterious Firehead Woman, thus bringing the narrative to a conclusion, and back to its beginning.

Reichertz's escape from the orthogonal constraints of the panel frame remains in keeping with comics tradition. Such comics greats as Winsor McCay, creator of *Little Nemo's Adventures in Slumberland* (1905), experimented radically with the spatial relationships between panels

to dramatise the dream-state upheavals of normal reality that Little Nemo experiences after eating (once again) too much rich food. Pages from 1908 show Little Nemo encountering himself as a cartoon character on the pages of a giant book, or Nemo and his buddies clamouring through great arched hallways that are upside down, then sideways, trying to keep their footing as the palace rolls over and over.[13]

More radically, the African-American artist George Herriman[14] juggled, altered the shapes of, or completely dissolved the panel frames in many episodes of *Krazy Kat*. Printed full-page in the Hearst newspapers' weekend sections from 1916 to 1935, it is widely regarded as the greatest comic strip of all time. The spatial and temporal ambiguities of these stunningly beautiful cartoons reflected the strip's narrative ambiguities, and the violently disruptive interactions of the characters, driven by the thwarted desire of Krazy Kat (a character of no fixed gender) for Ignatz Mouse, and Ignatz's compulsion to hit him/her, week after week, with a brick.[15]

Historically, the word "cartoon" (from the Italian *cartone*, "pasteboard"), meant "a drawing on stout paper, made as a design for a painting of the same size to be executed in fresco or oil, or for a work in tapestry, mosaic, stained glass, or the like."[16] Renaissance painters such as Raphael regularly produced cartoons, both for their own work and for the production of images in other media, such as tapestry.

Rather than seeing *Garbage* as a capricious appropriation of elements from another medium, one could say that Reichertz, in producing his "cartoon" images as wall-size paintings in acrylic and oil on polystyrene sheets, is indeed returning to the historical roots of both cartooning and painting, and finding there a fresh conversation between various ways of telling a story.

As a painting installation, *Garbage*, by emulating the formal qualities of comics, may trigger a sensory memory of the immersive qualities of the book, while asserting the claims of its own physical dimensions, larger than the viewer, with the characters appearing, in some cases, life-size. These are pages one might well imagine oneself inhabiting. Reichertz, having created his protagonist in his own image, can, like Little Nemo, see his reflection in the pages of a giant book.

— **Robin Metcalfe**, Halifax, 2016

ENDNOTES

1. Wikipedia, "Codex," https://en.wikipedia.org/wiki/Codex, retrieved 20 February 2016.

2. References to the Islamic disapproval of imagery are often oversimplified. Interpretation and practice vary significantly between different historical eras, cultures, and forms of Islam, with Shia Islam encompassing a particularly vigorous tradition of representation. By the same token, while Christianity has generally been associated with a broad use of religious imagery, a current of Christian thought that rejects all religious representation as idolatry has existed since at least the fourth century.

3. Within comics studies, the word "comics" is treated as singular, like "economics" or "poetics." The public book launch of *Garbage* coincided with the 2016 conference of the Canadian Society for the Study of Comics, held in conjunction with the Toronto Comic Arts Festival.

4. In the case of *Romanian Debacle*, that institution was Saint Mary's University Art Gallery, where Reichertz worked in the early 2000s. The series referred to the circumstances around an instance of catastrophic damage to a travelling exhibition of Romanian contemporary painting, arising from airline negligence.

5. Mathew Reichertz, artist's website, http://www.reichertz.ca/tiny-town.html, retrieved 20 February 2016. A slightly variant statement appears in *RBC Canadian Painting Competition: Ten Years* (Toronto: Royal Bank of Canada, 2008), p. 69.

6. Scholars had long assumed that Anubis had the head of a jackal, but recent genetic testing of remains associated with his cult suggests that of a golden wolf, instead. Wikipedia, "Anubis," https://en.wikipedia.org/wiki/Anubis, retrieved 24 February 2016.

7. Art Spiegelman had to reverse his images, as in a mirror, for the Israeli edition of *Maus*. Compare an excerpt from the Israeli edition in *MetaMaus* (New York: Random House/Pantheon, 2011), p. 154, with the original US edition of *Maus I: A Survivor's Tale: My Father Bleeds History* (New York: Pantheon, 1991), p. 119. In the Israeli edition, Spiegelman made several changes, including substituting a fedora for the uniform cap identifying a character as a collaborationist Jewish policeman, in order to avoid a libel suit from a surviving relative.

8. Scott McCloud, *Understanding Comics: The Invisible Art* (New York: HarperPerennial, 1994), p. 101.

9. Wikipedia, "Speech balloon," https://en.wikipedia.org/wiki/Speech_balloon, retrieved 20 February 2016.

10. John Carlin, Paul Karasik and Brian Walker, eds., *Masters of American Comics* (New Haven and London: Hammer Museum and The Museum of Contemporary Art, in association with Yale University Press, 2005), pp. 27-28. The name of the strip, incidentally, gave rise to the term, "yellow journalism."

11. Wikipedia, "Speech balloon."

12. Scott McCloud, *Understanding Comics*, p. 103.

13. Winsor McCay, *Little Nemo, 1905-1914*, introduction by Bill Blackbeard (Cologne, Germany: Evergreen/Taschen, 2000), pp. 130-131, reproducing panels for 9 February 1908 and 16 February 1908, respectively.

14. Herriman has been claimed as an African-American artist, notably by poet Ishmael Reed, although his social identity was apparently white. He was born in New Orleans to "mulatto" (mixed-race) Creole parents. There is evidence of his considerable ambivalence about his ancestry; he is said to have kept his hat on in most circumstances, to hide his hair. Stanley Crouch refers to him as an "ex-coloured man," using the terminology of James Weldon Johnson. See Stanley Crouch, "Blues for Krazy Kat," in *Masters of American Comics*, pp. 196-201, and Wikipedia, "George Herriman," https://en.wikipedia.org/wiki/George_Herriman#Race_and_identity, retrieved 22 February 2016.

15. Stanley Crouch, "Blues for Krazy Kat," *Masters of American Comics*, pp 194-201.

16. *The Compact Edition of the Oxford English Dictionary, Volume 1, A-O* (Oxford, England: Oxford University Press, 1984), p. 140.

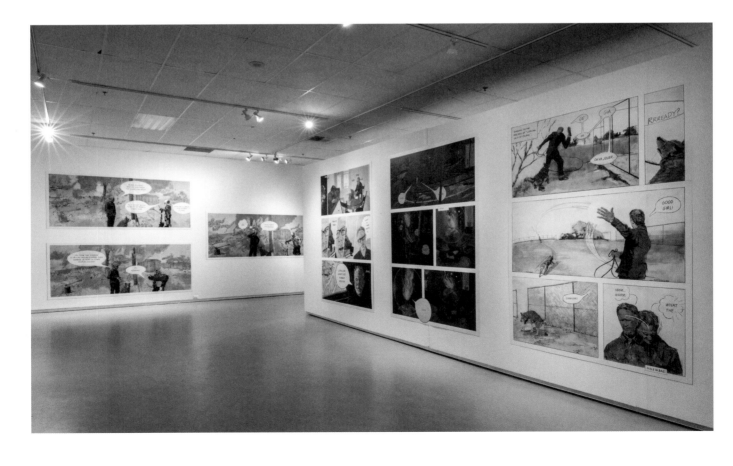

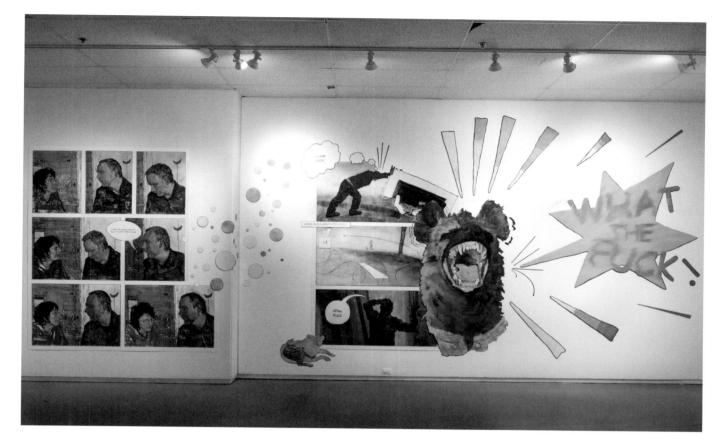

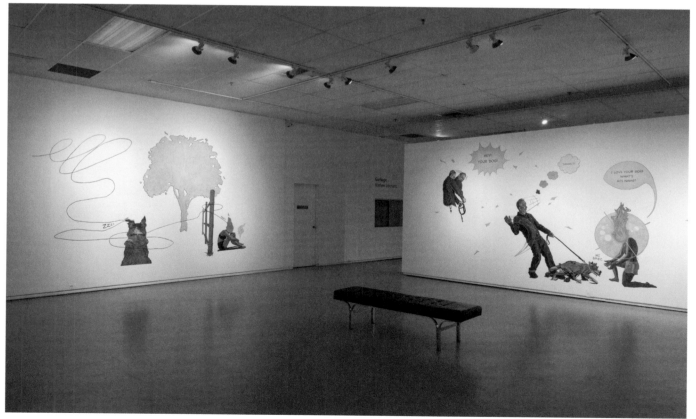

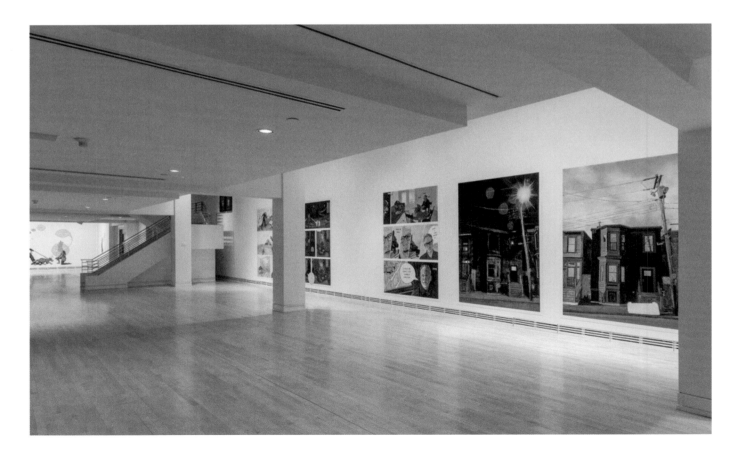

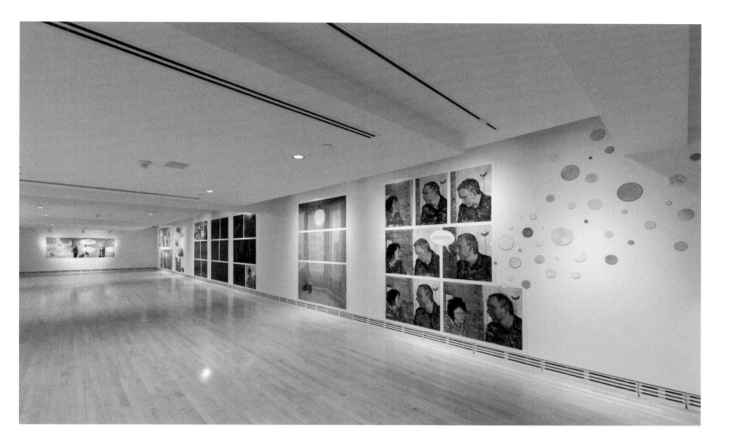

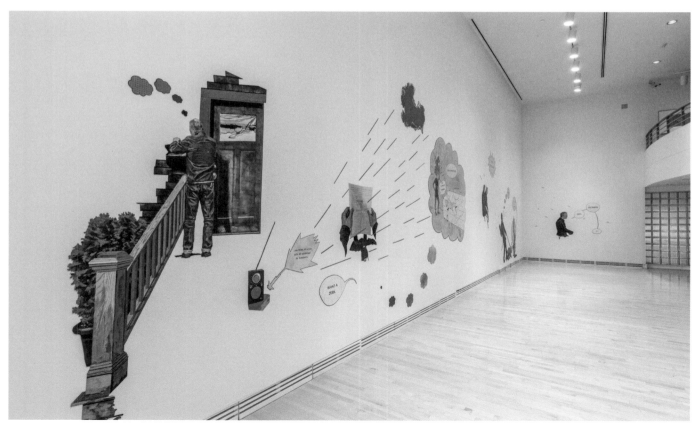

AFTERWORD

This book is the print incarnation of *Garbage*, a suite of paintings by Halifax artist Mathew Reichertz that appeared first as an exhibition at Saint Mary's University Art Gallery. It is, however, more than a standard exhibition catalogue. While it documents the work as it appeared in our galleries and provides interpretive texts, it also extends the work into a new realm: that of the graphic novel. Conceived by Reichertz from the beginning as a multi-panel narrative, drawing strongly from the traditions and visual vocabulary of comics, *Garbage* now becomes, with only minor adaptations, a visual narrative in print.

We are pleased to partner with Conundrum Press, one of Canada's leading publishers of graphic novels, to bring this project to an audience interested in a broad range of comic arts and artists' books. Over the past decade at the New York, London, and Vancouver Art Book Fairs, Conundrum's booth has been a friendly neighbour to that of Halifax INK, the consortium of university galleries and artist-run centres in Halifax that have pooled their resources to market their publications internationally. We are grateful to Andy Brown of Conundrum for undertaking this project with us and for his handsome design.

We are thankful to Benjamin Woo, an Assistant Professor in the School of Journalism and Communication at Carleton University, for his essay—casual, informed, and a little cheeky—in which he draws on his study of comics to introduce the work.

Saint Mary's University Art Gallery acknowledges our staff, whose work has supported the development, presentation, and tour of this exhibition. Pam Corell, Assistant Curator, ably supervised the installation at SMUAG, and shipping for the tour. Natalie Slater and her successor, Becky Welter-Nolan, as Administrative Assistant, handled paperwork and finances. We are happy to have had once again the services of Steve Farmer as photographer.

Carleton University Art Gallery thanks Heather Anderson for coordinating the exhibition, and Patrick Lacasse, Karina Bergmans, and Mathieu Pronovost for expertly installing *Garbage* in collaboration with Mathew Reichertz. Justin Wonnacott photographed the installation for this book.

Saint Mary's University Art Gallery receives operating funding from the Canada Council for the Arts and Halifax Regional Municipality. This publication also benefits from a generous grant from Arts Nova Scotia. Carleton University Art Gallery is generously supported by Carleton University, the Canada Council for the Arts, and the Ontario Arts Council, an agency of the Government of Ontario.

Most of all, we thank the artist, Mathew Reichertz, for sharing his vision and his provocative and witty paintings with us, and for helping us to reinvent the exhibition publication as a graphic novel.

<div style="text-align:center">

— Sandra Dyck
Director
Carleton University Art Gallery

— Robin Metcalfe
Director/Curator
Saint Mary's University Art Gallery

</div>

THANKS

I would like to thank Robin Metcalfe for his support of this project, for his delightful love of history, and his desire for precision in all things. Thanks also to Heather Anderson and Sandra Dyck for the chance to show this work at Carleton University Art Gallery and for their professionalism, insight, and graciousness. The crack installation crews at both SMUAG and CUAG were a true pleasure to work with and I'm grateful for their assistance. I would like to thank Andy Brown from Conundrum Press for his support and understanding during the production of this book. I would also like to thank Jack Wong for the thoroughness and care he brought to this project. I would like to acknowledge Arts Nova Scotia for its support.

Finally, I would like to thank Sym Corrigan for everything, Georgia for showing me how to be more human, and Ronald Reichertz for the idea that illustrations could be the size of walls.

— Mathew Reichertz

General editor and project manager: Robin Metcalfe
Design: Andy Brown
Printing: Transcontinental Inc., Quebec, Canada
Photography: Steve Farmer (Saint Mary's University Art Gallery installation views);
Justin Wonnacott (Carleton University Art Gallery installation views)
All installation images: Mathew Reichertz, *Garbage*, 2014
(installation dimensions variable, acrylic and oil on polystyrene)

Front cover: Mathew Reichertz, *Garbage*, Page 5 (detail)
Back cover: Mathew Reichertz, *Garbage*, Page 4 (detail)

Legal Deposit – Library and Archives Canada, 2016

Library and Archives Canada Cataloguing in Publication

Reichertz, Mathew, illustrator
Garbage / Mathew Reichertz ; introduction by Benjamin Woo
; afterword by Robin Metcalfe.

ISBN 978-1-77262-008-5 (paperback)

1. Graphic novels. I. Woo, Benjamin writer of introduction
II. Metcalfe, Robin, writer of afterword, organizer III. Title.

PN6733.R44G37 2016 741.5'971 C2016-900928-9

This book is co-published by Conundrum Press, Saint Mary's University Art Gallery,
and Carleton University Art Gallery. It is supported by Arts Nova Scotia,
Halifax Regional Municipality, Carleton University, the Canada Council for the Arts,
and the Ontario Arts Council (an agency of the Government of Ontario).
Conundrum Press acknowledges the financial support of the Canada
Council for the Arts and the Government of Canada through the
Canada Book Fund toward its publishing activities.